Iftheywokeup lthemthattheycamefromth esunt moon sthats ulsgl owan uhave becon voeon scomp keupi nthen ldtheli ghtbexcvbnmqwertyuiopa sdfghjklzxcvbnmqwertyui opasdfghjklzxcvbnmqwert yuiopasdfghjklzxcvbnmqw ertyuiopasdfghjklzxcvbnm

child of the sun man of the moon

selected poems and writings of Judah 1

art by steven lawrence

Dream. Attain. Release. Repeat.

Dawning of Shadows at Sunrise

1. 11-12-2010
2. Made you up to hurt myself
3. High Fire
4. Sleep. Write. Metaphysics.
5. Holding onto freedom
6. Lucy
7. Far Truths
8. Shackle my sunshine
9. 6 of 30
10. Face the Flicker
11. Mindmeltedfragmentedfaith
12. You did this
13. Where God is >
14. God is a Sound

In the Fullness. Compacted Aeons.

1. I hear the fall
2. I hear the fall (rustled)
3. 11102010
4. Certain Centers we are
5. Altered altars 3/30
6. Night before yoga
7. Posers. Bikram yoga
8. 7 is the harassment of the day
9. Atomic fireball
10. Kanye shrug
11. Double entendre
12. 5242010
13. A poem for my Negus

Even.Ing

1. Expel the Shadows

2. I learned they were right

3. Closest Second

4. Ms. Rowena

5. Holy Verses II

6. Holy Verses III

7. Time won't tell. Observed. Digested.

8. Home game

9. Sleeping in it

10. Tatted cause I'm scarred

11. They Boys

12. From the Inside

13. Double Negative

14. Hard times in Mind

Moon Rising. Cascading Eden

1. Allusion
2. Desire caused the Sun
3. Rock climb in hijab
4. Danger I desired
5. White noise
6. Sub-Atomic
7. We came
8. Polar and paradoxical
9. Certain scents
10. Makes the wind linger
11. Day One outside Eden
12. Masha'Allah
13. Holy Verses 1
14. Amin
15. God is a Sound II
16. Returning
17. Chanted. Dark and Obsidian

18. In the ashes of love gone Boom

Such Cider

Out of the Darkness came Light.

Dawning of Shadows at Sunrise

When the profession of your baptism is discounted
flee Babel.
Return to where the tongues make sense to your hearing.
Cries of the priest will rule an empty temple
full of faith fueled by Roman edicts filled with blood.
the problem is eastern belief in western systems
don't mesh
like Gilgamesh in Cuneiform in English history books
until you know your sources were outsourced
and admit that
Your trash will be recycled.
Your burned books will be cataloged;
fragment till whole.
The Holy isn't available to monopoly;
board of games,
chess matches between laymen and clergy,
checkers between confessors of the same God
King me.
Queen the pawns you've dethroned.
The heretics are coming
with crowns cast from the gold that's been smelted,
with the original versions of the stories
and old names
and faith that the stars remember existed
before their reflections were slain on earth.
The sky will give heaven back to our hands
and we will give
what greed makes men pay for
with their lives.
Because we profess faith in the same God
with different phrases
from the culture we know
with words not so foreign
and you will know
that you have starved our prophets
but mistakenly exported their sons as slaves
who remember the names of their fathers.

Made you up to hurt myself

I just made you up to hurt myself.
Wrote your name in the dark,
chanted till the day came.
And it came
as it always does.
There I lay
in the refuse of what dreams may come
came true.
They normally do.
I awake not knowing what happened
again.
It occurs every so often
then the hindsight
the free write
the finger-paint on the wall
reminds me of the vomit spit
the blood spill
the seizure
the blackout on white pages.

Seers see more normal in the future;
we live in the present crazy.
Clarity is scribbled by men made mad and abstract

There was a contract I made within myself, I suppose.
Let the hemorrhage swell;
it is well when my soul submerge,
it is well like the Prophets say
in the face of destruction they wrote.
I choke on secrets left unrevealed in the most honest of writing.
Coded like my name in the TORAH
in a certain sequence in only the old Hebrew script.

I just made you up to hurt myself
or to give myself a reason to hurt,
another may say
Ashe to my Amen.

I feel what I did not before
or hide in a playground during recess.

Random memories from the recesses
make themselves prevalent
when you connect the dots,
constellations,
signs and symbols etched in caves
on tablets burnt and broken,
in tree bark;
colors spark forgotten passion
left more appreciated in the forgetfulness.

These papers thrown about me
are the fullness thereof...
subconscious songs of freedom
fulcrum at hand
on the precipice of papers un-ruled
untamed
uneducated in bullshit
or at least lessening the scent on my brain stem.

A writer's winter

pen and pad, cold
I get old fast when this happens
actually everything does

High Fire

More high fire than past stars
Spent till faded dimensional
Physical principals forgot sole authority
Forgot soul authority
Sol jurisdiction
Mason-Dixon non-existent
Like borders be
A map of man's imagination
We imagine somewhere holy they'll be
More High fire than past stars
A certain memory of the cosmos
Lines in my palm tell me
Where we must be
Been there before
Here all the time
More High fire than past stars
Abstracted flawed heroes
Roots of the Kingdoms
Many rain dances we made
Many reigns we danced thru
Many kingdoms we reigned
Till the rain came and washed
Our Jerusalem Babylon's
We made a temple reaching to the clouds once
In worship of ourselves
We used ourselves for the hard parts
Put ourselves up on high parts
And used ourselves as slaves
Till we forgot who our selves were
One like true Adam
Mankind not men
Divided we stand waiting to fall
More high fire than past stars
Shooting across a night sky screaming
In a language only Angels know.

Sleep. Write. Metaphysics.

The electricity sounds like screaming
in my sleep;
a low hum when I wake.
Silence has a sound in the city

There are strays in the streets
climbing into cars
loving every stranger;
new road kill in the morning,
last breath in a low hum.
I heard it when I woke
Then the electricity brought it to my TV;
relatives, screaming.

I think I see the future when I sleep
But I'm not dreaming.

It's like a mirror
Watching you back
With another mirror in front of it

A thousand MEs
And some of them are moving
A thousand MEs
Yet, they all speak in unison
In their own languages

Woke up with metaphysical spit
Dark Matter shrouded it.

This is subconscious Akhenaton
Prototype for Moses in my prime
papyrus mingled with moonbeams
Nah mean?
Probably not
the answer's unlocked
in last year's lobotomy.

This is the living memory of the surgery
from the vantage point
of the neighboring Frontal Lobe.
Nah, I'm not crazy.
We've all had the same surgery
designed to keep us as slaves
Extracted Divinity.
What do you think some of us go searching for?
We feel God missing here
Acknowledging mysteries
In spaces that we knew before.

Holding onto Freedom

I stole some phones and sold them
blamed it on the recession
so they promptly gave me a cell.
Reception always at full bars
in court they read me a text
it had several sentences.
Now Bubba watches me from the bench-press

So it's a big deal
Obama's President
Promise change to the nation
Here, we get stagnation
change don't come when you up in the Pen.
Pin pictures on the wall
my girl removed our pictures from the hall
I couldn't vote him in; a felony conviction

Now that I'm out again
I cant get a job again
what happened to my job placement?
Truly, this nation needs rehabilitation
its been a year
i never land a second interview
Labeled "criminal" like Crime is what I am
Thought I was a man.

Bubba thought I was a woman
Got more time
had to show him what I am
When need be my fist be diplomacy
Locked me in some Hell
what was the change that you thought
it would bring to me?

Product of my environment
In my mind, I escaped

Books kept the iron bent
Outside, they assume "beast"
question my intelligence
Provide their own answers to the questions
they pose to me
I'm feeling Pharcyde
as jobs are passing me by
Wrote letters to y ex girl
just to pass time
they were never returned
When they let me loose
told me, "Make sure you never return"

Burned with a brand no one wanted
but its on my record.
A record that nobody wants.
Nobody buying stock in me.

They tell me keep my head up, chest out
like a soldier headed off to war.
 My war is on the streets
the streets are in my mind
my mind is like a cell
but I'm holding on to Freedom.

Lucy

Sometimes the angel inside
only looks like a monster.
Creation is often
masked by disaster.
A phoenix looking caterpillar
just before the fire.
The glassblower knows the essence
of a Serpent is just a Dragon
waiting for its wings to be blown out.

Pride masked for bravery,
slavery for freedom.
We have free will for free trade
but the rights are not equal.
You were both
Morning Star and General.
Purple Heart, Dark Amputee
I wonder if there are still sores
where your wings used to be?

Squirm like a worm
Lucy,
remember
you are not one.
Remind them
a dragon only drags its belly
cause the weight of the fire
but can still take to the sky.

I wonder
if you were the only angel
created with a rainbow in the eyes?
Gold Pot Promises;
your tongue
an oasis with no benefit.
Sweet venom,
flame throw intentions

Human kind still mesmerized
by the fire
we must be
it must be
the reason we still beg
kiss me
fang me
bite me
burn me
scratch me, scratch me, scratch me.

Inflict pain with our permission
Drink the blood I spill for oil
blood I spill for gold
blood I spill for greed
blood I spill for lust

Trust me
we want you
Our Dragon
we'll feed you our first born

Our Angel
our own piece of divinity
that never says, "NO"
when we asking.

Sacrifice our life
a small price to pay for our passion.
The root of that is Latin
Passion: that which burns you.

It's evident
our chosen Angel
Lucifer
Lucy
Our Dragon.

Far Truths

When told far truths
thought to be to be lies
We crucify
We can't be that, Jesus
They said
You can't be here, yet

We slain our best reflection
Humanity beckons Man
Man pleads for other Ones
Inner Unity too difficult
Give us an External
External, too make belief
Too much like We still
Rest long without movement

These Dark Ages got bright lights
Blue screen doors
Thru which we let in the FOXes
Glazed over now scales on our eyes
Sleep to the Lullabies
Every regular season and playoff
Soaps for the brainwash
Primetime just in time to interrupt
Last self-reflection

Broken dreams result when
We see too much should not
Cause self-reflection make you see God
And God is not to be bound
So we turn around inner vision
Slave free
free slaves
In and out of Egypt

When told far truths
We restrain ourselves in religion

Accuse the closest to the Farthest Truth
Of blasphemy
But we blaspheme against ourselves still
We accept gods; deny ourselves much
Which is called sacrifice in theology
But take what I said literally
We deny ourselves much
we know what we deny
deny what we know
cause they say no from they're angle
telling we about our frequency

Did not Humanity internally have Liberty?
Authority is what we give to others
That is, till we come to maturity
And learn our far truths.

Shackle My Sunshine

Shackle my sunshine
Free it when you need it
My light was always set
Work for you
Sound the alarm
Find me ready at the gates
Watching
Peering into the darkness
Translating your understanding of all
Those wounds you thought
Were inflicted by the Devil
Were just the result of you
Tripping over stones
Bones mended broken
Fragile thoughts passed down
From the Star, Crescent, Vatican
Strengthened by blood and fear
Of spilling
Fear of
Losing is winning
There is Hell at the gates
Heaven in our hearts
Both in the same place
The same shape shaded
Light for the dark
Dark matter occupies the rest
Compressed mineral ethereal
Behold, the soul glow radiant, translucent.

There be shade between us
none grey.
No purgatory in our speech
just pain from sustained torment
shield in hand
knife in teeth
razorblade buried bloody beneath skin
in case of emergency:
dig into thyself and cut your way out.
I am but a witness to your goodness
no friend of the executioner.
Whomever. Wherever. How ever.
they are. come from. many they are.
few are we. stand with. Retreat not.

The sparrow will watch and honor our defiance with song.
His eye will watch the sparrow that honors us
as I heard a song say
You are always armored in Sunday's best
Pajamas sometimes should have knowledge of Sunset and Noon
We moon our light much too often
Moonlight our lovers
pray before dawn
Osiris know how Horus come early
ignorant are we mostly
Religion runs rampant without true Philosophy
the Sun-God was not born Today nor Yesterday
Tomorrow. Same different.
Witness East and West on a grain of rice
Microcosm
we are closer to the cosmos
than we can think, mostly
We are never lesser us
only lesser gods
I propose
Create or be Mortal

Face the Flicker

When they come for me
I will go
They will call and I will answer
And I will burn
On my own terms
like Monks for Justice
Or
Burn at the stake like many
Martyrs before
For a stake in truth
They burn and light the world still
we saw ourselves in the flicker
Our faces glow too

MindMeltedFragmentedFaith

I swear
I tried to kill them
but they would not die

They were in my eyes
They did not exist
But you saw them too,
Mirror

Sounded like broken before
My holy
Sounded like broken before
The God who gives
Amen

It's finished
Lost fragments in scripture
That did not exist
Prophets spoke in fragments
We accepted as whole

Broke the mold on every individual
We are not amoeba though
We do not exist
We are images of a powerful
Imagination
Standing as gods
Reading books we wrote yesterday

You did This

You did this
Mess I am
Beautiful.
You knew
Somewhere in yourself
I'd come from
Why this part
Am I, Lord?
How am I
Not another part
Or parts more?
You did this
Planned kamikaze at birth
Blueprint blood map
Vessel, I am
Rushing to die
To some plan
I don't know
The reasons escape
Like water in my palms.
There is evidence
I know once.
1st thing I
Yelled upon arriving
When I was baby blue
Like the sky
I feel I came from.
Did I come
From the blue
Like some monster
Lord, I am
A beast like them?
Is there a
Beast in you
Where goodness dwells?
Is my household
A den then?
I reside in you
At least where
I was come from

Did you evict me?
Was I not good?
Did I rebel with the light bearer?
Did I not uphold the light?
How long am I
Banished to flesh?
My brothers know
Who they are
Inside but everything
Changes when it
Comes out, Lord
What is it
About this place
That make our
Blue blood red?
Even Red Sea
Knew we were
Not to be mingled
The Color. Purple
Is divinity
Death the only
Time we stop
Changing while blue
Red mix we
Return to an eternity
That only flashed
while in flesh.

Where God is >

The symbols are bigger
Than I poems I write
Ancient concepts of here and now
And thereafter
Hereafter
Hades sounds like some earth
I know
And heaven too
And God sounds like
It often has hands
But we know. It is.
Formless and Transcendent.
And with us.
And some of us know
We there already
If the beginning is the end.
It's over
I'm chilling.
In the cut of the universe
Where the Angels call
Black Holes Black Mothers
And Black Stars are born
And burn blue and purple
Black stars burn
Blue and purple
Cause darkness know divinity
The mystery is on our side
Our dead don't seek after life
Not as the living do
Might consider their state
More blessed
More rest and peace
Like when my eyes close
And my peace seize
When I see black

And thoughts go into the darkness
Behind my eyelids
Is where God is
Out there
And here too.

God Is A Sound

Gimme a sound that sounds and I will see
Let there be
Was strong enough
Then came Light, I heard
The story say
God is a sound somewhere
Inside Itself everything exists
Inside Itself everything emits
Nothing moves without The Sound say
Nothing moves without making more sound
And echoes.
Rippling Dark Matter
We hear turbulence as wrath in this plane
God is in the language
I've been telling a thousand tomorrows
Yesterday remembers my voice shrouded
In a cast iron bell,
Every orgasm
A baby's breath
Stars hum Hallelujah, I hear
The Fullness
Seen an Aeon named Sophia
Translated as Wisdom
Ignore the unknown to you
Hear it again till it makes sense
Read aloud
Cause this must be
Let there be
Somewhere the supposed stirred within Itself
As if Big Bang ain't in tune with old religion
Yesterday remembers when we told you
The Sound said then it was
As if always even
In silence, the slightest whisper sends shockwaves into ten thousand
tomorrows
There are many whispers in a day
There are no end in echoes infinitely smaller than an Atom's blink

Think about this as Tomorrow causes the effect of its own infinity
The blind man saw himself safely home from the journey
So turn off the lights
Whisper to the silence
Listen for the echo
Now let go

In the Fullness. Compated Aeons.

The leaves rustled
the courtyard sounded like an ocean
I thought of you
close to where the stars hum
the origin must be near to your new from
I'll return soon

The leaves rustled
the tele sounded like a psyche ward
I thought of all the loose things
security and sanity
are but a wrinkle in time
you'll find me in the creases

The leaves rustled
the sidewalk sounded like a cave
I thought of bats
blind because love knows better
I closed my eyes and danced on a precipice
laid my coat over the storm drain.

The leaves rustled
the street bent like branches
I thought of tire swings
barrel rolled the full circle
I jump like Kamikaze
there is sand in my eye

The leaves rustled
the scent strong like residue of morning love
I thought of your warm place
clap until we have an audience
I shiver a hallelujah
there are no words to say

I hear the Fall (Rustled)

The leaves rustled
the courtyard sounded like an ocean
I thought of all the loose things
the tele sounded like a psyche ward
I thought of you
close to where the stars hum
security and sanity
are but a wrinkle in time
the origin must be near to your new from
you'll find me in the creases
I'll return soon

The leaves rustled
the sidewalk sounded like a cave
I thought of tire swings
The street bent like branches
I thought of bats
blind because love knows better
barrel rolled the full circle
I closed my eyes and danced on a precipice
I jump like Kamikaze
laid my coat over the storm drain.
There is sand in my eye

The leaves rustled
the scent strong like residue of morning love
I thought of your warm place
clap until we have an audience
I shiver a hallelujah
there are no words to say.

11102010

probably shouldn't put oranges in the first line
I have poetic license
but there are no boranges to etch
in the stones of three gorges
natives inscribed the gorgeous
master architects of the west
can scarcely get jobs
some become street florists
others street pharmacists
in other states they get arrested
just for being at the same time
foreign and indigenous
cumbersome
nuances are nuisances when you dictate
your reflection onto another
you who would claim Christ but deny justice to your neighbors
are strangers to the heaven in your hands
master plan: Manifest Destiny
you get what you stole for
sold for and bought into

you be the highest bidder of hypocrisy
demanding disclosure of WMDs
and unleash chemicals on your own people
Statue of Liberty say open
read documentation slow
squeezing millions through peepholes

the rest are poor and disenfranchised
mind on overthrow
but the heart is weak from cholesterol
mind on overthrow
but schools designed not to teach us better
never overthrow
cause creditors say our number is getting better
for better or worse
we blind or not strong enough to lead

Certain Centers we are

There are certain centers we are
In orbit each of us
Interlocking like webs worldwide

This thought thinks more math
Migraines from divine mathematics
Mere mortals migrate to Mecca
More so Darkness sustains Light
Light shrouds darkness
So there
Remove the covering and pray
There
Here is where you might be again
Tomorrow we orbit
And return
So there.

you cannot understand religion without symbols
you cannot understand symbols without metaphor

They tore thru the ToRaH
cold climate pale fingers.
There was history they assumed simple.
Complex was the poetry to the point of sciences;
tied it with they politics.

It was the story of a people
told by other people
before they were people.

Names behind the altars were altered;
corruptions made by the corrupt.
What did we expect
with the Kingdom of God
in the hands of man's empires?
They called themselves Sire
Kings and Lords
over mire:
the faith over and in and under
Capital
flags
pledge allegiance to and in
the man with the biggest army
sending sons to wars with use of little pens.
We die for things that don't exist
ownership over lands we'll never own.
Fighting over principles
but we're in different Schools of Thought.
Thought it was all Peace
till we got caught
in between slavery and capital.
Money be the root of all
every kind of evil.
Shepherds herding the sheep
sheering them in the winter

and leading them straight to the precipice.

When God made the whole wide world
they say it isn't HIS
lies to the kids.

Night Before Yoga

Pack me in a pinprick
Fold me till I decibel
You posers allowed me
To pack myself in a box
Of my own frame
Named something I can probably not pronounce
I renounce the impurities
From my body
obviously,
I mean you see me
The skinny guy
sweating buckets with no shirt on
I WAS WATCHING YOU watching me
I know you posers get turned on
Turn the heat on just so much
Submit to the balance
Harness our humanity
Namaste

Namaste
I'm having a meeting with
Old borders at this junction
This junction lined with yoga mats
With hands where the feet were
And heads where the knees be
And heat where the heat be
These posers like it like that
Like that and that

...They flexible...
Dammit I will be too
But next session

I'm coming with no clothes on.

Posers. Bikram Freewrite

Sweat rolled down her thigh
And dived off her knee
Like pieces of the puddle
Return to the puddle
From the bend of the crane
She was bent like a crane
I knew she'd fly
Rather I believed she could soar.

7 is the harassment of the Day

again.
Again I was spotted doing good
this makes the beast salivate
this gives the cat a mouse
He trailed me, I spotted him plotting ill
I turned on corner. Watched. Exited vehicle
Entered liquor store. Bought starburst.
My sweet tooth has eluded me fully.
He passes by, I know his plot, I did not elude him fully.
He passes by again. I wait. He waits. He circles
I leave. His circle is full. Gets close enough
then the U-turn. Lights flash.
Blood pressure higher.
he exits vehicle gun drawn.
Says my car has a warrant.
He and I know, asshole
didn't see plates just color.
no car just human
it must be easy to fill your quota
with a badge and ill intent
to stress a poor man
you molest my peace on a peace filled day
I got another ticket I cannot afford to pay
Hallelujah.
Hallelujah
Hallelujah, Anyway

Atomic Fireball Freewrite

Hotter than the fireball
rolling around my tongue
you are...
and elusive.
You would break my jaw
as advertised.
When I was a lad
you almost proved yourself.
Still I manage to leave
bite marks on your surface;
don't worry, your reputation
will be intact.
I got you covered by darkness
you bring the heat.
Our residue is flame like?
Actually the aftermath of my words are
after we met today.
You would be the Delilah to my Samson
in between these two Pillars, I write
You right my wrongs in cinnamon.
I know your bends, never-ending
You've learned my tongue, never-ceasing.
Here in this moment
in the midst of art
we spark our own.
Like flame in mouth
and sweat on brow
those closest know how
you raise my temperature
on already hot day.
Your center be the sweetest
part of you
My tongue drips
on the inside parts of you
over salivate
over satiate
my sweet tooth not self sufficient

but dependent on you
in this moment.

Kanye Shrug

Kissing your lips is like
seeing the stars at point blank range;
that flame.
You the moon that orbits my planet
that orbits your sun
in turn.
Rubbing so deep till the Indian burn
on the inner
thighs that warm my ears like muff.
I often
use double meanings
excuse my triple synonyms.

I love it when we
use whole words in our conversation
no acronyms
we're not made of gingerbread
between us, there's no shortening.

We often
quickie with a double backbone climax,
think about it later.
Memories don't last like people do
we did it real big
cerebral
I got that ass
IMAX.
Optical on the sparrow
finger round the nipple
tongue on the c*it.

You love it when I
drag my tongue along your hip bone
and blow it
sensation
goose bump
tasting

finger licking good
that ain't all the licking though.

Double Entendre

Exhausted before you came
used the last ten minutes of life I had left
to wear you out too.
I'll send you off
smiling in the morning
your dawning is awe inspiring
let me see it again.

I will not dream tonight.
Dreamt less since you came
come often.
Let's get you keys to this place

Heaven has a gate in our embrace.
Brace yourself for this glory,
neighbors did hear
Hallelujah in the morning.

Still there is hell in our space between.
Memories so distant
they like past lives
that haunt us.
Judges from within
question us.

We persecute ourselves sometimes.
This time we found solace.

Oh silent night,
I marvel how you applaud us
and echo our claps

These walls can talk, Love.
These walls exude scents in the summer.
These walls sweat like we do.

Them walls like brown sugar.
them walls layered like Lotus.
I meditate in the middle
intensified when I'm lifted like Buddha.

double entendre

You walking a little stiff, still.
I walk you out holding my back.
Teenage neighbor stopped me
climbing the stairs to my apartment
just to say,
"Homie, you swag out!"

Silently I chuck the deuces.
In my head I know
that's true shit.

Dueces.

5242010

We are the last rays of a distant Sun.
Shine on.
Shine till your grandchildren
leave God to walk into our light.
Allow Pluto to melt in your smile.
The family tree will become a constellation
for Orion to depend on.
Shine on.
Radiate and gravitate.
Breath life with a soul glow.
A fist full of manuscripts for God to read
when so ever He passes time.
Shine till you expose the prism
that holds the frequency
that separates men and angels.
Melt the bars that bind us.
Let the light
that we once knew be called "Dark"
in comparison to the new day.
Collectively, there is a Sun
emanating from the Space within us.
The God rest on Sunday
rises from within us.
Truly, there be an untapped beauty
in our beast parts.

A Poem for my Negus

Why must we fall into winter so cold
I hear of men that radiate
that absorb
with skin that make flesh photosynthesize
carbons into oxygen
they breathe like trees do
they take sunlight and purify it in blackness
exhale mercy on oppressors
they fuel
carbon like coal
they burn to absorb
fire that would destroy.
eternal like snakes symbolize
shed skin and forever young
summer make black
and black don't crack
how old are they?
darkness is still a great mystery;
Are they those divine people
that raised the Buddha?
"Nagas" they were called
Those" Mons" that brought knowledge
and had Monasteries build in their memory
Monsoon come "Hither India"
said Ethiopia
and they home again
the strongest winds are named after them
masters of monsoons and also overland trade routes
"Negus" they called themselves
Rulers and Architects each of them
Prophets and sons of light
they so dark they absorb it
and radiate on the world
Those Nagas call themselves so
greeting in peace
sounds like" Niggas" to the ignorant
over time Nigger

in ignorance they corrupted the meaning also
like the names of our prophets
they preach from the books we wrote
stories we told our children
metaphors to sciences coded for more melanin
my people perish for a lack of knowledge
under educated on purpose
ignorance spreads corruption
now Niggas they call themselves
truly, they have forgot themselves

effectively, what we recognize as royalty
is a curse here
some of my Nagas
want to ban our title
cause of the corruption
its hard to even deal with ignorance so deep

So i should let my Negus go?
I will never let my Negus go.

Even. Ing.

I stand still like a tree and leave.

Expel the Shadows

Used to expel every shadow in the day
then I embraced the ether.
Lost my religion in a secret
escaped from NIMH;
Still stumbled on mice in cages.
My surprise
and to my chagrin,
moral victories remain largely winless.
Masters of degrees and not much more.
less than they went in with;
in terms of dollar signs, I mean.
But signs don't matter
unless they're green of course;
one too many courses and not enough paths.
Education was a manifest destiny
till the bottleneck came;
calculated says my personal conspiracy.
People don't listen to theories anymore
just FOX news and the like.
It is likely we are bound merely perceiving freedom
in shackles.
Debt equates slavery
how many institutions do you owe?
This is what revolutions are fought for
I know your history, America
the way you got free you deny.
Gorilla warfare.
Roadside attacks.
You were Israelis struggling against Rome.
Were Palestinians occupied by Israelis
and then you became the oppressor.
Often a cycle remains so.
You never changed heart just manipulated.
Sold tickets to a show you never really understood.
Freedom without Justice never stood
will never stand.

You kill just men who dissent peacefully;
black socialists and white presidents
are as mulch on fields next to monuments
in drought blood keeps you greener than the other side.
Fit for holidays never meant to really be holy
just as reminders as to what will happen
when you go after the seven heads of the beast.
Babylon will slay you and put your head up in books
cause stakes aren't effective anymore.
Stakes is still high.
Warning the elementary subconsciously
of dissent;
we resent Justice here.
We'll invade you for Pepsi-Cola or Halliburton.
Capital is a white house of green backs
stacked against the populous
there is money made mostly from the hungry.
Seeking after what we see
the hungry will eat anything.
A Statue called Liberty has on a tablet,
"Give me your hungry".
They feed us shit.
Give us chitterlings by the bucket full
hog maw and pigs feet
take this and eat and give thanks
scraps from master's table.
Pray for your piece of the pie
but dessert is for those we say who deserve.
the rest of us serve thirsty.
Pray for your peace with our pie
but God will not hear you
we give false names when we conquer,
we lay claim to the altered.
Holding on to promises
while reservations are made.

I learned they were right

That poet with the bug eyes was right
the bug eyed ones see more anyway
he say, "You will change. Just as God does."
I denied both like Peter
although it took me longer than the cocka-doodle
that was five years ago
I don't do the poems that I once did
my stances stepped back a bit...
maybe more forth
my faith became the greater predicate
change.
wider and deeper and somehow maintained my frame
yay, even greater I maintained my frame of mind
climbed higher than I once were
looking down on clouds I did look up to
I miss that city view
I mean the traditions
the meaningless meanings we give our authority to
pearls cast to swine
that's a great way to hide knowledge
right along the shit within the populous
I remember when I didn't cuss at all
prayed every morning
came home every night
1 of the 3 remain

the deacon that was scared
that his daughter was majoring in philosophy was right
she stopped going to church because she knew too much
I was a philosophy major too
haven't made the vacancy
but I feel it like a vacancy
that's kind of semi occupied

love me like an infidel
pray facing east anyway

center of the sun rays
the wrinkles give chase
hint at my mortality
I'm a sinner anyways
in debt till my death paid

I didn't change
I believe what I did before
I did change
I don't believe the same things the same way
figure that's okay
none of us have solved for X yet

The Closest Second

Last time I saw you
I drove away in a rental
fortunate to catch every green light for a mile
I needed that much distance to swallow your smile
good thing little cousin is mature enough
to let a grown many cry at a stop light
choke it back together
continue conversation when it turned green
Gran-daddy, I love you
I say it like those are the only words I mean
Inshallah, I hope to see you again
Amin
Amen
Amun
Ashe
I'm afraid
every time its time to visit you
You look just like me
Rather, I look like you
we the same size
we can still wear the same size pants
Afraid
every time its time to visit you
One time when I was younger I admit
I pretended to have a stomach ache
so I didn't have to visit you
Because I cry every time we drive away
distant at close range
It hurts me
knowing that I may not ever
see you again.
So I'd rather not see you again.
It's selfish, I know.
You are my eyes last reminder
that my Father's side is half Blackfoot Indian
The other half sons of Kentucky slavery

Some figure blessed are we
to lay our hair straight
next day blow it out, Afro
no chemical.
They say we "got that good hair"
to me this hold no benefit.
The older you get the more I witness
the passing of my lineage.
Wee are African of unknown origin
We the same height
same measurement in melanin.
You got smoke gray eyes
sometimes smoke green
other times smoke brown.
When I was a child I was scared to look into you
You reminded me of the "Exorcist".
Now when I come around
you proclaim God's awesomeness.
"He's mighty boy! Do you know HIM?!?
He's awesome and merciful."
We both shake our head
in a thankful disbelief
knowing only half fully the measurement of our miracles.
We watched the BET Awards;
you knew all the latest rap songs.
Got up and danced to Lil Wayne, "Stuntin like my daddy"
"Awww shit! This my Nigga. This my song right here!"
"Stuntin like my daddy"
"Stuntin like my daddy"
My Daddy watched and smiled
my eyes held a marvel.
Watching you is a glimpse
of what an old me will be.
Mouth of the hustle turned honeycomb.
You call me "Sugar" when I come
and "Honey" when I leave.
It's kinda odd but makes me smile.
I see you the least
I'm like you mostly.
From the Hustle to the Honeycomb,

small frame to the melanin,
to the dead cold stare intensity
followed and only equaled by the balance
of an immense eye smile.
Forgive me for denying you my face in those younger days.
My ways are more mature now.

Ms. Rowena

1918-2013

Ms. Rowena,
You told me your parents were sharecroppers.
Reminding me how old we
are and how new
this "freedom" of ours really is.
Reality hits
I imagine
The heartbreak of each harvest
How did a sharecropper react
To not getting a fair share
Of the crops they grew
A fair share of what's sold
I'm told what you don't remember
In books
Fairness was a non fact
A fact of life as it were
Was
Is.

How beautiful you were
Three husbands said, I do.
Loyal you were
Loved each till death
Untimely as it were
every time
Each left you with more
Kids to tend
Ten in all
Perfection till the end
That continues
Ten the completion
Your D.N.A. Download
Twenty five years
Between the first and the last child
My mother who worships you
In fond memories
Smiles echo you

Live still

Kept the house clean
somehow you did that
Along with all the other homes you kept clean
Housekeeper by day
Instructor by night
Other children you raised and taught
You bought a mansion on lay-a-way
Heaven is made by hands
That work scripture like yours

Faithful to the Lord.
Fifty years in the same church
Mother to many
Many times over
over segregation
You crossed over
Bore your cross
I see Harriet in your Jesus
Black in your high yellow
Cherokee in the blood
Reserved from plantations
As it were
You keep feathers in your hat
As a reminder of that
Your blood knows slavery and freedom
Now I teach kids in hope
Your D.N.A can free them
Brown boys.

Holy Verses II

When discussing race
most sprint to the finish
on the track provided
by the same ones who oppress
perhaps this is the only race
the black man cant win by amazement alone
monuments to mark we been here
changed the situations
but not the face on the bills
bills that bound us free
dollar bills; we slave for they faces, still
they faces still in mine reminding me
we ain't really free, yet
slavery was abolished not made illegal
we are currency in this Bank of America
The Bank called America adds interest
Occupy any street you want and they'll pay
to have you removed
Wall Street will remind you of your old hymns
"Bridge over troubled waters"
corralled like sheep
now the Walled street of Police face freedom
and remind you that your civil rights
are left to the highest bidder
this is above "Nigger" but the undertone remains
Urban, poor, unemployed, uneducated
we blamed for the schools
you didn't build and don't fund from our taxes
we ask for Whole Foods you give loans to Liquor stores instead
Nature vs. Nurture is not a question
we know the answer
our blocks are developed like Soul Food
stripped of all things home
we evolved into culture
you inject our culture with commercials
Hormones

and Capitalism
those who wanted what you got
die for illusion
those who reject
die for a sense of better being
"How long? Not long!"
Says Dr. King
but those are statements of a King
there are too many Pawns on the streets
too many Hoes
not enough Queens
Check yourselves
you are surrounded indeed
by a million black men who are learning
like me.

Holy Verses III

there was a spring deep in my ankles this morning
which I immediately noticed cause they have been hurting
so my morning coffee walk had a little bounce in step
the way heel to toe hit pavement
and sprung up
reminded me of almost 3 years
that wore my sole out

felt like doing push ups in quick sand
it was exactly what i asked for
stand in submission
and drown in dreams coming true

all i wanted to do was breath
and that's what it came down to
all breathe is is life
so all I wanted was life
death was the hard part
and I died
and again and deeper
till all I wanted was life

there are graves for the living
most never climb out of
there are graves we climb into
without the intention of dying
just comfortable in warm confines
when Free you'll see everything as a prison

break
strip
scatter
burn
melt
cool

Repeat till pliant
then disintegrate nearly
mingle with another
become a new thing
 its called life, death and life or resurrection
its also called Alchemy

the battle to be better wages in me
Jihad, I've heard it called
oddly enough, its also called Submission
this is also Alchemy
this is also Metaphor
this is also Myth evolved
this is also better
better also means More
closer to perfection
following in Christ's steps
mimicking my own.

Time won't tell.
Observed. Digested.

Metal has a feel .
Blue more than a color.
Sons are more than seeds.
Our needs are just desires we pawned to acquire,
the answer to his question:
suffering is universal my friend.
They raped him till he put their answer in his mouth.
Disgusted as I watched them
shove scripture down his throat.
Unbalanced as a slave master proclaiming his mercy unto slaves.
Chains bind the same even when you don't see.
The free carry shackles in opinions.

Picked his jaw off the floor .
Wiped the spit .
Spit the rest.
Stood straight .
Resist and they will flee
"and come back with seven stronger than themselves".
Confused as to why so vicious
void of an answer
or rebuttal to the beat-down;
the Atheist in a room full of Christians proclaiming to be Atheist.
He wasn't brave he was honest.
He didn't have an answer so he questioned.
The response lessened my belief
that we are more mercy
than our fathers or our conquerors.

Time won't tell our true stories.
History will be revised and dark ages will return.
the Vatican will reboot.
Jerusalem will rebuild.
Jesus will return again.

We'll beat our weapons into plows.

Plows will micro into chips.
Chips will enter into net.
Squeeze till we pixel.

Return to shards in the mosaic of life
blaming one another for the shatter.

Home Game

Here
 I still need to say your name.
Today.
 Tomorrow.
The day after tomorrow
I hope not to say the same.
 Change this arrangement.
 Become Ether to my memory;
 Forget me.
 not.
 Maybe.
 I haven't shed a tear
 because you left me.
 Perhaps.
 I have too many other things going on
 to feel yet.
 Just maybe.
 I have so many things to find
 I don't have time to see I'm lost yet.
LEFT
withAcluster
 I have not the will to manipulate
 Access the Alchemy.
 This will result in a better being.
"Be in" me
add a "g" when I'm older.
As of now
I'm just human;
later I'll be a human Be-Ing.
 Perhaps
 I'm an Alien to first emotions,
 "feeling" comes when I reach second base.

Earn
Home base
still lose,
why celebrate?
A score
Is not enough.
Home plate ain't mine
I'm the visitor.
I
could lick the plate clean
Still, kitchen not mine.
The field may be good greens

Here.

This is not my stadium.

I still need to say your name.

Today...I win
Tomorrow...I lose.
The day after tomorrow
I hope not to say the same
Next time we
compete

It'll

be a home game.

Sleeping in it

Now I lay me down to sleep
In the middle of the last place
We made love here once
Slept in what was made of we
Woke up in dreams of you
Dreamt you into my awakening
Was inside when you woke
Hold still
Still I lay now
And silent
listening to echoes
Watching the aroma lift
Off the walls around
Walls within crumbled
Still for hours alone I listened
Meditated on your laugh
It sounded like "Om" once
Watched you dance like Shiva
I am imagining
The radiance
Dancing in my thoughts of ages golden
For moments at least
Dervish due to ecstasy
Dancing due to memories
Experiences in Paradise
You bring Eden to our table
As a man I bring Cain cause I am able
Pain is universal
Moons are not immune too
Footprints of the Meager
You loosen what I knew would hold me here
Giant leaps are because I draw near
It was clear I would love you like this
Day one

Tatted cause I'm scarred

Tatted cause I'm scarred
not scarred cause I'm tatted.
Today would be a good day for inkblots
blood clots got us stuck here.
Scabs for the scavengers and bedbugs
empty cups for the thirsty.
Decisions made
repercussions are final.
Some build landmarks
so they don't forget the feeling.
I get marks just so I can get the feeling.
Sometimes I feel empty and blank,
sketch me a filling.
I already get dark when the sun shines;
Child of the Light.
eleven times I beckon the sun to burn me
Lotion my raised skin.
Fighting my ash,
Mom says I hide volcano.
I burn. I burned trees.
Past tense
Tree of Life in a sense. Death follows me
Knowledge of Good and Evil.
Eyes know what the mouth can't muster.
I trust her
she trust me
we break.
I scar
I mark self.
Remember why in the mirror;
Silence is the weakness of the strength
refusing to show anger.
Silence also acceptance.
I accept consequence.
Tatted cause I'm scarred
not scarred cause I'm tatted.

they boys.

They boys
They play fight and slap box
Use foul language and push boundaries
Tell mama jokes
Get defensive when they go to far
Them boys they often go too far
Trying to prove themselves
As men that they aren't yet
Sex self educated
Single parent raised
They boys
Often on the same wrong road as their brothers
Mothers cry for them
They boys far from home and freedom
Freedom got them detained
No one restrained them boys
So they are here
Teaching me about the hood
We escaped from
I gave my mother something extra
On mothers day
In memory of these boys I teach
Trying to reach and extract them
Their mentality reaches my tear ducts
Faces feature in my prayers
They just boys like I was once
I hope they become better men than I am now
Teaching poetry is often halted
When I question
why Are you here
How long
How does this feel
Bars can't hold their dreams
I give paper
Teach them how to write

Others how to spell simple words
No, "girl" is spelled with an "I" Not a "u"
Some too gangster to ask
Or write emotions
So they draw
I wonder if they draw what they hear
If that is the case
I hope they are listening
I got a story to tell
Not just a lesson to teach.
Not a preacher but this is spiritual
Parables
Divinity in hood abstracts
Them boys asked me to write about them
I didn't know where to start
Now I don't know where to end
See I teach poetry in a detention camp for boys
Twice a week I see them
Happy to see them smiling
at least when I come
Saddened I see them smiling
Hear them joking
About doing the same thing
That got them boys here
When they get out
Really just saddened I see them at all
Bars are not the place
For boys or animals
I never go to the zoo anymore
One of the boys said they are animals
I refuted him
Saddened that I even had to
I leave them tired cause I care more
Wish we had more time
Wish they had no time
They boys.

From the Inside

They have the eyes of their children
but they men with hardened smiles.
They will spend their lives walking the same mile,
I hope to bring smiles from the inside,
"from the inside".
This phrase has double meaning.
They who have changed from the inside
know they will never be outside
find themselves here. Inside the same walls.
They self reflect and write poems.
They self project and write letters to their seeds,
to their mothers
those who remain.

They amaze me.
They here and will remain so.
I'm here to teach poems,
we talk God mostly
and meditation
and coping
from the inside.

We free write, share and listen.
exchange perspectives
and stories.
They tear up over mistakes made
over children left behind
and love taken for granted
and places they will never see or know.

They were young men
who made the mistakes of young men.
We never talk about why they are here,
I never ask.
"Never" is a word I attempt
to never say around them.
Unless used in certain sentences like

"Its never too late".
Sometimes that message seems futile
but since there are points even in Forever
I spread this good news.
You can be free
from the inside.
They inside so they know the power of perspective
perspective is all they got.
Perspective is all I work with.
We work in poems
but speak in symbols.
There are metaphors for Tomorrow
I told them Yesterday.
Secrets of the spirit coded in rhyme form.
We learned fixed forms
and regained the formless.

The spirit cannot be bound
unless you have bound it
or relinquished your name
or forgotten yourself.

I hope they continue to write in circles
till they evolve and revolve around themselves
each man in his own orbit.
The point of some poems
is to orbit
to give points
where we can check ourselves.
We write stations of healing
and build alters in the mind
I hope they find
the outside from the inside.

<u>Double Negative</u>

I searched for your heart
like W.M.D.s in Iraq. I mean
I had to give
those who supported me
reason to be there.

I listened to the allies I had
forged in my own head. They
convinced me of the fact. There
was something in you?
Worth fighting for.
Packed on a precipice.

Perhaps I listened to the crowd
too much; Reality, there was no crowd.
The allies always say what I imagine
projected on the screen I call eyes
The Weapon of Mass Destruction
is synonymous with the love
that I so desperately wanted to find
in the echoes of you.
To give my members
my limbs...a reason
to be outstretched
like they are.

A rally...a search for ghosts.
But I am no Ghost buster
at the end of the day. There
was no Indian in the Cupboard. Just
a cowboy and a manifest destiny
for self destruction or maybe
Just destruction.

I looked in you for something
You told me upfront you didn't have.
I wore out my welcome after

banishing your demon.
Hung your dictator.
Ripped a new one in you. Manipulated
when you wouldn't love; my gloves
are bloody black. My intentions
are blurred. Remove my coverings
I'll blame it on intelligence
I received falsely.

Maybe I should have carried the "one"
or dotted that lone "i"
or crossed my "t"
I've been crossing you too long.
For so long I've desired
the gold beneath your desert.
Created my own mirage and called it
by your name.
I didn't plan correctly. Your sands
jammed my machinery.

I came.

gave myself no timetable
to get out if I couldn't subdue
Your resistance too numerous or perhaps
didn't commit as much as I told
My members...my limbs, outstretched
for too long the danger of being
an emotional amputee grows
with each battle

I mean
I ought not be here.
Came to you with visions; now
my dreams are bloody black. I imagine
Coming home and finally
laying into a hug from my mother
with no way to hold her back.
My arms, my limbs; I mean, my members
were lost next to the mirage

in the moments of the ambush
at the beginning of the day

You told me you couldn't commit to me.
Over zealous as I often am. I compensated
Over committing to you.

I will make you love me
or at least write it like I believe it.
Rehearse my words until I can
convince others when I say it.

Tainted love. I am
prostrate. Facing East
Lapping up spilled oil
from the depths of the gulf of me

Cause here
Remorse tastes like I knew better.
You knew better. We all knew better.
We always seem to know better.
We never seem to do better.

We promise to do better
with our first love, second wife
But forget when our Smart bombs fail
And the strife replays
In Afghanistan.

Love me like

our Gods were

at war

and we were

trying

to make peace.

Hard Times in Mind

Hard times in mind
Like forever
And Nothing as Infinite
Bear witness to your perception
And testify
Your truth or your lie that seems so

Show us light with no perversion
And we'll know darkness
And origins of myths
Chart the cycles
Sound waves
In lengths we might measure
As holy

Forever is hard to find
It's a hard time to mind
Or fathom like the deepest depths
Of the sea
Even in Moon risings
We stand on calculations
That succeed in falling from grace
Too exact for mercy unseen
Signs and symbols subtract
What science may
Add up
What we randomly
Have known
And believe to be true
Like names as long as Pi
Unknown like the Forever origin
Or end
We guess
We know not what's true

But some call forever by name
In silence

With breathing and a thought
And become as commanded

There are planes you can pass thru
They've passed you
presently tomorrow
hear the echoes calling back
For your voice

Knowing you deserve your piece
Of the Pie
And every slice is just as infinite
Know thyself you deserve it
You slice of Pie
You infinite
Not finite
they lie like Satan
Promise the world like the Jinn do
Capitalizing on your desires
They enslave you.

Moon rising. Cascading Eden.

Book IV

<u>Allusion</u>

I could tell you that your eyes are the future that I cried to see at my
birth...
But, you might not be ready
probably wont believe me
after all, I'm a poet
I have a way with words.
an alchemy with phonemes
pupils are full of sincerity and silence
I often stammer in person
my mind overflows and i have a slight delay mid sentence
I tense
I freeze
my palms do get balmy
you think
I have my way with words
the birds don't have their way with the air
nor the fish with the sea
currently
I'm speaking in currents
contrary to popular belief
I don't catch the flow so often
my words come from where they came
We ask for the truth of their origin
like we wonder where God comes from
the question in yourself
keeps you from believing
keeps you from seeing the better beautiful before you
If I affirm, "Believe only half of what you hear"
then let my name be the lie
my words are my truth
if they be illusion they be for my personal allusions
I'm delusional like the best prophets were
do you blame the brush or the artist
for the pink water in the painting
if perception is reality
maybe he sees your blue as pink
if perception is reality
we all live in a myriad of illusion
but maybe the most sane of us all
speak in allusions

your eyes are the future
I cried to see at my birth.

Desire caused the Sun

my desire did cause the sun to shine upon us

you thought it only flashed

raise the flag half mass

Hafiz says "there will be holy fallout"

I pray you learn how

meanwhile flame fades meteor

the snowball gave breath to the avalanche

when the day before the ice age came

I noticed how cold it became

and only then

Rock Climb in hijab

Stooped down and presented
Palms up
Drank water from her cup
The cup was her hand
I'm not her man
But I drank

She's fresh like the rain
Her reign will be fresh
Queen of my heart
Covering her majesty
She rock climbs in hijab
Runs miles in the rain

Outlined with eyeliner black
Closer to Isis
Like Osiris
I want her to all see
Odd rocks in our path
Places we can cross water
Both drank from the crescent of your hand

Squeeze light from the crescent of my eyes
We blink then open and see
We eclipse again

My reflection blocks your pupils
Back to me
Its your shadow in the center of my eye

Deep space and orbit
Breadcrumbs
Bits and pieces
Dark Matter Distance
God in every other sentence
And in silence by the inch

Sweet scent
I caught you
My tulip in a dry river bed
Puma by the waterfall
Wet where the ice melt
New Balance Princess
Rock climb in hijab

Danger I desired

the best parts of me remember their names

when you touch me

touch me no more.

Heaven is in the knowledge of self

depths a hell only know to breech

you must be the danger I desired all this time

White Noise

I will love her

in all the silence

of all my favorite songs

chopped and screwed.

Loose are the meanings

packed tightly between thighs

pressed gently against chest

smile upon the mess we made.

Replaying pillow talk

as the prayers of Cherubs imagined for us

a million yesterdays

ten thousand tomorrows.

In every age ago

Impression deep pressed in the heart of God.

Depression in the hearts of those

who would be

but never will be

our lovers.

Stunted crushes

midget next to our Nephilim.

Our hand hold Semitic languages.

I write Akkadian Cuneiform

into your back.

You called it a massage.

I call it the names of children.

The dreams of Fathers.

Your smile one of Seven Wonders,

Hanging Gardens in Babylon.

The desert is made to know our beautiful.

The Sun is made to nourish our blossom.

Hebrew Prophets call

the scent of our love made

the Rose of Sharon;

places more East

title our position Lotus.

Look into me but don't speak;

Synchronize breathing;

Tantra our lay down;

Chant a psalm in my image;

Find your mantra in me.

Om Shanti Shanti.

Repeat till. Peace. Bangs.

in three full explosions.

Ears glow red

like my love be napalm to flesh.

The hair we pull singes

good pain

push back and cringes.

Fire down below?

lick to douse the flames.

Flames in the mouth?

Down low be fresh waters.

Drinking one another because we enjoy the taste

not because we are thirsty

but if we do thirst

we obey body

I obey mine as long as you obey yours.

Sub-Atomic

If we find the time
I'd search a sunrise in you
Probe your darkness
Till the light come
An alien like abduction
Lead to new revelations of self
And crazy questions
Asked to girlfriends
About explosions
Sub-atomic

We came

We came
Now that we're going again
I remember to whisper
Since the neighbors already know my name
We came
Like humans after dinosaurs
Evolved slowly
drifted to where waters flow
Left our scent adjacent to every oasis
There are trees etched with our markings
Backs etched with tree bark
Sap and seed everywhere
We came
Till our dreams were populated
In less nightmares
More daydreams of reality
Only battling for love
Never over it
How can we be?
Jump away from a globe with its own gravity
You just come back down
again and eventually
Love is like that globe, you know
Love has its own special gravity, too
You will leave but come back again
with a longitude slightly shifted
We gifted in goodbyes
But we bless when
We came.

Polar & Paradoxical

I like the way

the taste of your breath changes when we kiss

like licking storm clouds

then the thunder

water flow

rain on earth

hallelujah of broken silence

messiah formed feminine

delivery of divine sentences

silence in scent

alphabetically

c before d

curiosity comes before desire

then the emptiness shall ensue

sue me for enjoying creation

and proclaiming glory in things non

religious

somewhere there is a star named

Darkness

that still shines

stars hum Hallelujah, I hear

That's the rumor spread in the Gospel

polar and paradoxical

the cause and the effect is Hallelujah

the beginning and the end is the

same

Glory be to the Creator of this

moment outside scripture

within bounds of the boundless

maybe I praise I own will

some may say something of this sort

***i say they hoes that lack

knowledge of my Holy***

when all is sorted they will not be

found lumped in my sum

sum of parts but part of the whole

cant add me if you never learned my

equation

I ain't revealed that yet

they guessing

like the living do heaven and hell

I smell future in your center

how many licks does it take to get to

the world may never know like children asking questions

even owls have no patience to answer sometimes

in short I say Hallelujah in lieu of answers

Hallelujah for the blues that come as they do

Hallelujah for the passion that leads us to flame

and the fact it grows cold enough to build fires

burn till we run out of kindle

hopefully we hold heat till the dawn

when the sun comes we might see

beyond the smoke of the night offering

the King on the other side of the pit

proclaiming a Hallelujah that we found a way

to last the night together.

Certain Scents

certain scents I know I'll miss

.your breath after we kiss
.the summer in your shoes
.earlobes
.what your dress does to the air as it flows
.the slobber you left on my chest
.the sweat from your fingertips on
.my everything
.one thousand steps in the sand
.the smell you leave in my hand
.pillow talk
.your tears
.your plaque in my toothbrush
.the Fall in you
.I fell for you like hungry men do good meals
there are certain scents I'll know I'll miss
.

un-named because I respect you
.the way you made my back a scratch and sniff
.your scent lifted one man to the Moon

Makes the wind linger

What is it about you
That makes the wind linger
In your scent
I am still

When the wind blows tornadoes
Thru me
You're scent occupies these senses

I's see hurricane in your stillness
My fingertips perspire you when I'm nervous
I am only nervous with you and the law
I am lawful only with your permission

You often permit me
To taste and see that the Lord is good
Gimme a sound that sounds and I will fill your backbone with kisses
Feel your eardrum with whispers echoed
The day knows only night should hear
Names in this tone

Five senses covered
Blessed with a sixth
Ether is made when we kiss
Then we inhale our divinity
Literal no imagery
We have Dark Matter symmetry
Combine our waists to a fulcrum
Maat in our balance beam of Moon rays
Old lamps bear our names
Stars hum, Hallelujah
I hear your name echoed from a yesterday
Light comes from so far
And sound comes from the deeper

We know the Infinite is just a Voice
That only sings as a choir
Within star burns

That heat makes cosmic wind linger
'round your circumference.
In your scent is a gravity
I am pulled till I am still.

Day One outside Eden

they that first rubbed

sticks together

caused the first fire

that saved the first night

they lay together

without god

inside

Masha'Allah

rifts rise between mountains
because mountains are best when rising alone
We believe in giants
and angels
and God's will
and separation of powers
when the balance is thrown off
such gravity the earth cannot muster
we spread
on creek sides and white sheets
we pure in our immoral
but we are not immortal
we believe in giants
and angels
and God's will
we submit to peace
when love means war
Islam (peace) the sunset
Jihad (internal struggle) in the dark
we await Moon risings
midnight is a climax
peace in every language is the same
it is mostly covered in every place
like you from the East in the West
make my mother understand Mary more
keep men from sinning
you helpmate to humanity
ornately colored but so far from vanity
your hair, I should not have seen
but when I did finally see the shimmer
Paradise was cascading
deep brown like Eden's dirt
curls spelled Allah in Arabic
I see HaShem in everything you do
the way your eyes tell me truth
the way you hold pain back

I wish your people were like you
I wish my people came from you
cause we believe in giants.
MaSha'Allah

Mā šā' Allāh (ما شاء الله) is an Arabic phrase that expresses appreciation, joy, praise or thankfulness for an event or person that was just mentioned.[1] Towards this, it is used as an expression of respect, while at the same time serving as a reminder that all accomplishments are so achieved by the will of God

Holy Verses I

Loved you till I would die for the hope to love you again
you good like sunshine on my melanin
tan my desire black and more mysterious
I was not curious when I saw you
knew what love was then
pursued the would be that did Become our synonymous
you and me walked till she and I became We
love pluraled our singular

tradition always fought new divinity
god resides in the spaces between you and me
its the only time where less is more
our hands hold Peace when our hands hold
eyes know Amen as reflection
It is so
so are You
Amen

I am pleased with my prayers come true
especially that each one lead me to you
good was the plan behind my submission
bad was my planning sometimes
ill timed rhymes
blame my internal meter
its off sometimes by a full measure

when I'm projecting I go thru your eyes
you beautiful window to Heaven all men should know
you invoke my testosterone
make me see stars and colors in scent
your silhouette bends Sun to halo
a Holy Woman you are and modest
honest unless it hurts
otherwise silent then laughter
You crazy like I am, you know?
I am after you, still

I am after you, Moon.
Even when you crescent.

AMIN.

You revive dry bones
Buried in the desert.
You took my high, I mean
You lightened my load, Amin
Suckled dreams on your breasts
Like a good woman should
Smart eyes twinkle
Even at night yours sparkle

What did you do
To the memories of my past loves
I only remember the here and now
Call it the Great Hereafter
Afterburners scorch After-Thought
Memories of your smile burn me
After you leave
You are here, still

Disciplined enough to still flames
Otherwise not denied, I mean
We have conquered one another's passions
At least another night, Amin
Or "Amen" like my mother say
She did also say
"Boy, you better keep that Moon"
She beams, Amin
I say Ashe to that last statement

Tasted the forbidden fruit
Found the Tree of Life as but a seedling
At the center of your core
Now I know why Adam called her Evening
In you is the summation of all
The wisdom in the day
And we know you are rib still
And we know Ribs are as shields for the insides

I study faith and the religions of man
And all it lead me is to your eyes
"God called his son out of Egypt"
I was ready to call mine out of Palestine.

Page102

God is a Sound II.

OM
radiated the Light

Darkness responded in self manifestation

OM
radiated the Light

in shame the Shadows hid themselves
manifested as shells more hollow

Nothing moved until The Sound came
all froze when The Word danced
look past me in ecstasy
see The Sound within says Shiva
God in motion is God at rest
old science say:
It just is
separation of states
as prisms
and planes
came after Eden
before death was necessary for living
we are what we eat
we dead already

The kingdom of God is on earth
He said
it is all around but you perceive it not
it to, He said
we heard everything else as static in motion

we assume rightness from all angles left behind
left behind by the rapture in a time
distant to now

if we had waited
blue jeans would grey over many summers
if we had waited
we might have faded too

there is a Bell that Sounded Before Once
only it rang and Then became Now
every echo an eon
every moment vibrates into more moments

if you look long enough at a thing stagnant
it moves
like mirages do
as light pulsates
as Sound travels

Ether is no mystery
we held by it as is all of space
Dark Matter the Science say
God as element say more Ancients
the sound that bonds composer and orchestra
outside body within the instruments

Heaven is this
when control ourselves
Om

Returning

Yet there is turbulence
There in the peaceful moments
Of my life.
When my breathing is disrupted
And I return
To worry about an illusion
Or an allusion from yesterday
My mind breaks its own silence
Just to grapple with itself sometimes.
These lines are broken
This page is a mirror
This God,
A pre-fix to the Transcendent
We are
Not just ourselves
And we know One
When our eyes close
In peaceful moments
And be still breathing
And struggles overcome
And we still breathing
There is life
Leaving like Trees do
With seeds that sow themselves
Self fulfilling prophesies
Each Spring they are
We do spring too

<u>Chanted.</u>
<u>Dark and Obsidian</u>

As my stomach pushes
My heart into my throat
I speak love
From several sources of ashes

A silent pain thrashes
Tears through ducts dried up.
How does one mourn love?
Love you are still in possession of.
Love unfulfilled.
Like forsaken promises
Passed by glances.
Lent over Passover
As it were;
Almost Easter in Spring.

Passion of my Christ
Sacrifice the similes.
Move on to sacred metaphor...
I Am
Archetype asexual

Create myself over
In reflections
In echoes
As ripples,
Chanted as poems recited as scripture
As they were.
As they were, once.
Once there were as
Concepts created under stars.

I called out the constellations next to you.
When you were next to me
They connected.
When you left; new mythology
And new old lessons to be learned.

How quick the Quicksilver really is?!?
I blame the moons by multiples
Divided by the square root of Ether

An invisible sightseer

Seer of words
Through tones made ripples
In my dimension back to memories
that slip future
and you;
A Present Tomorrow from Yesterday.
A muse of forever type impact,
worthy of nightmares
and manmade religion
and spells casted by consonants

With descriptions of your frame in mind
I rant to many listeners
And they hear the unsaid.
The should've voiced vowels
bubbling my bowels.
Like radio waves without transmitter
You are on my frequency now.
Dialed in sometime over an absence;
A distance satiated by regret and 3 sorrows

Let me borrow your hollows
Till holy they become to me
And wholly we return

Burning past silence in blaze;
We smoke signal
We rain dance
We war cry
We fashion arrows
And decorate them
According to our fashion.
Cupid does not fit us.

Aiming with long bow
And squinted eyes,
With pierced ears we listen
For a sound to make us fire
Hot arrows from fresh friction.
Dark and obsidian
Like our pupils in shadow,
Like our melanin in a Summer too long.

I'd sing you a song
But I can't raise my voice
above my heart
Which is lodged in my throat still.

<u>Such Cider</u>

the cider inside her
has the hint of blackberry
and marinated cherries
in blossom like the lotus
she was
still is, folded
in layers best known to herself
and an eastern sun
known to enlighten
everything that orbits

In the Ashes
Of love gone boom.

in the ashes of love gone boom
the rose grows gray and wafts one scent, atomic.
hair follicles know a change in DNA is next to follow;
an evolution through the Ancestors exploded like stars.
darkness at distance in darkness
is closer still.
Apostles testify
we are under a great cloud of witnesses.

in the ashes of love gone boom.
banks built on the burials of Natives;
This is
capitalism over corpses exemplified.
blood born economics in increase
yet diseased.
"Recess" signals a break
where I'm from
they not from here
in truth, I'm not either.

in the ashes of love gone boom.
plantations are built then reservations.
no reservations on actions just acting;
sorrow on the silver screen.
silver spoons from Old Jerusalem
hidden in a cave.
desecration shall come from the beast

in the ashes of love gone boom.
baptisms are made in Babylon
in rivers made toxic.
they will tell you are clean.
take this food and eat.

it is dead.
so are you.

Peace and Amen.

About the Author

Poet. Author. Teacher. Activist. Believer.

David M. Oliver began performing poetry at Church and at A Mic and Dim Lights in Pomona, Ca at the age of 16 in 2000. Taking on the name of "Judah 1" at 22. David Oliver has toured the U.S. performing spoken word at Universities, spiritual rallies and poetry dens.
Judah 1 founded LionLike MindState Poetry series 2008, which has provided a platform for him to teach poetry in Prison and Detention Centers and provide art services for Inner-City Youth.
Member of the 2005- 2006 Los Angeles Slam Team
Coach of the 2009-2010 Empire MindState Slam Team
As Co-Owner of Machine Pomona Art Gallery, David Oliver has also become a community organizer and inspirational community figure.

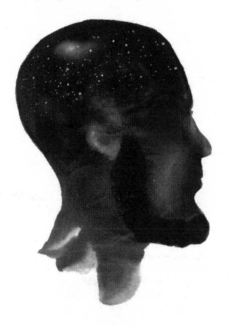

Artwork by Steven Lawrence